How to Draw
Dogs
In Simple Steps

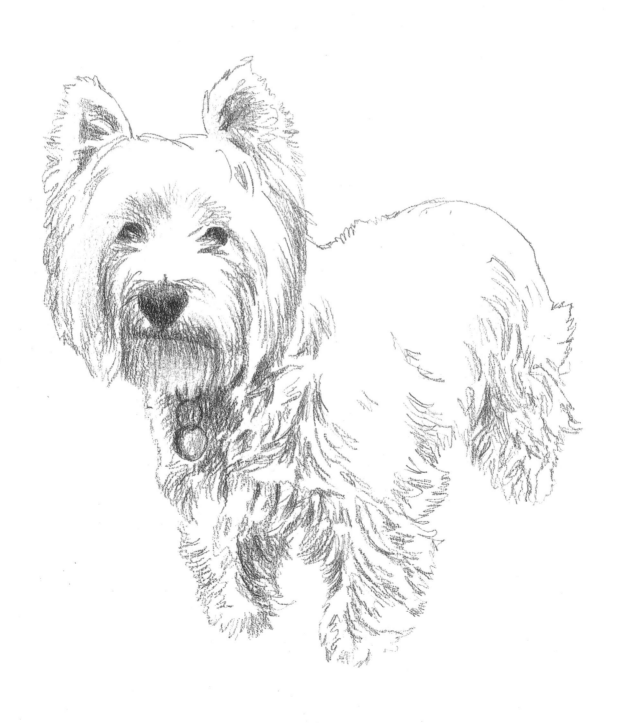

First published in Great Britain 2009

Search Press Limited
Wellwood, North Farm Road,
Tunbridge Wells, Kent TN2 3DR

Reprinted 2010, 2011 (twice), 2013, 2014, 2015

Text and illustrations copyright © Susie Hodge, 2009

Design copyright © Search Press Ltd. 2009

ISBN: 978-1-84448-374-7

Printed in Malaysia

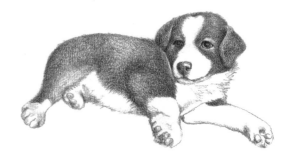

Dedication
To mum and dad

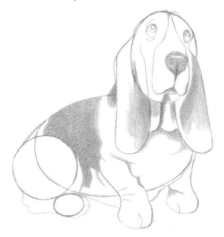

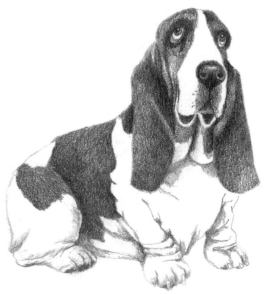

Illustrations

How to Draw
Dogs

In Simple Steps
Susie Hodge

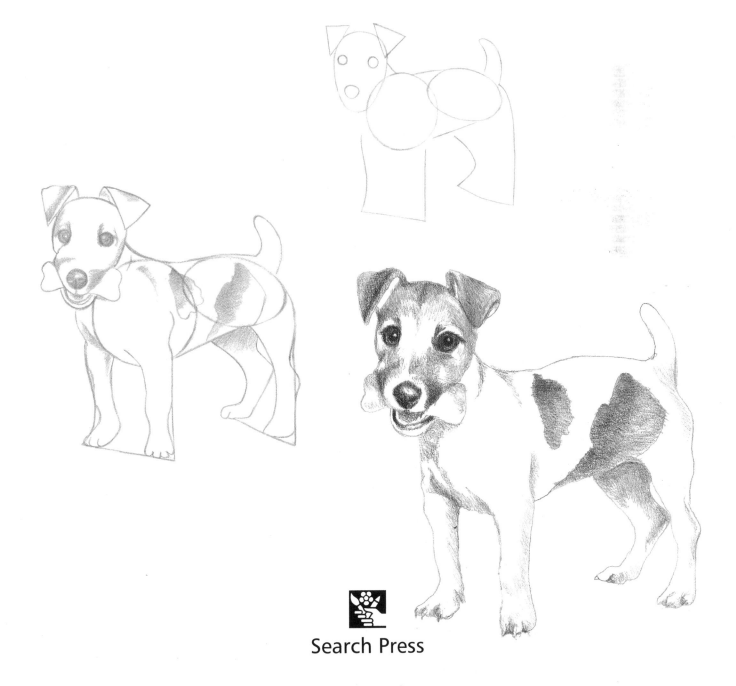

Search Press

Introduction

Happy, healthy dogs can be a pleasure to draw, whether they are handsome, cute, dignified, elegant, funny or scruffy. On the following pages I show you how to draw a variety of breeds, starting with simple shapes and building these up in stages to produce drawings of specific dogs. In order to make the sequences easier to follow, I use pink and blue coloured pencils for each of the five stages.

In the first stage, the head and body are reduced to simple, circular shapes and drawn in pink. In the second and third stages the previous images become blue and pink is used to add new shapes, such as neck, back, ears and legs. In stage four, the pink shapes are developed to include distinguishing elements with an indication of fur, paws and facial features. The fifth stage is drawn in graphite pencil and further developed to show form, bone structure, texture, tone and character. Finally, I have included an image of each dog, painted in its natural colours.

When you are following the stages, use an HB, B or 2B pencil. Draw lightly, so that any initial, unwanted lines can be erased easily. Your final work could be a detailed pencil drawing or the pencil lines can be drawn over using a ballpoint, felt-tipped or technical pen. At this point, gently erase the original pencil lines.

When you feel more confident about your drawing, you may want to introduce colour. I have used watercolours, but you might prefer to use coloured pencils, acrylics or pastels to create good effects.

I hope you will draw all the dogs in this book and then go on to draw more, perhaps from photographs of your own, or friends' pets, using the simple construction method I have shown. Try using tracing paper to transfer shapes and lines to your drawing to make the process a little easier. Once you become familiar with the general anatomy of these loyal and affectionate animals, you will grow in confidence and soon develop your own style.

Happy drawing!

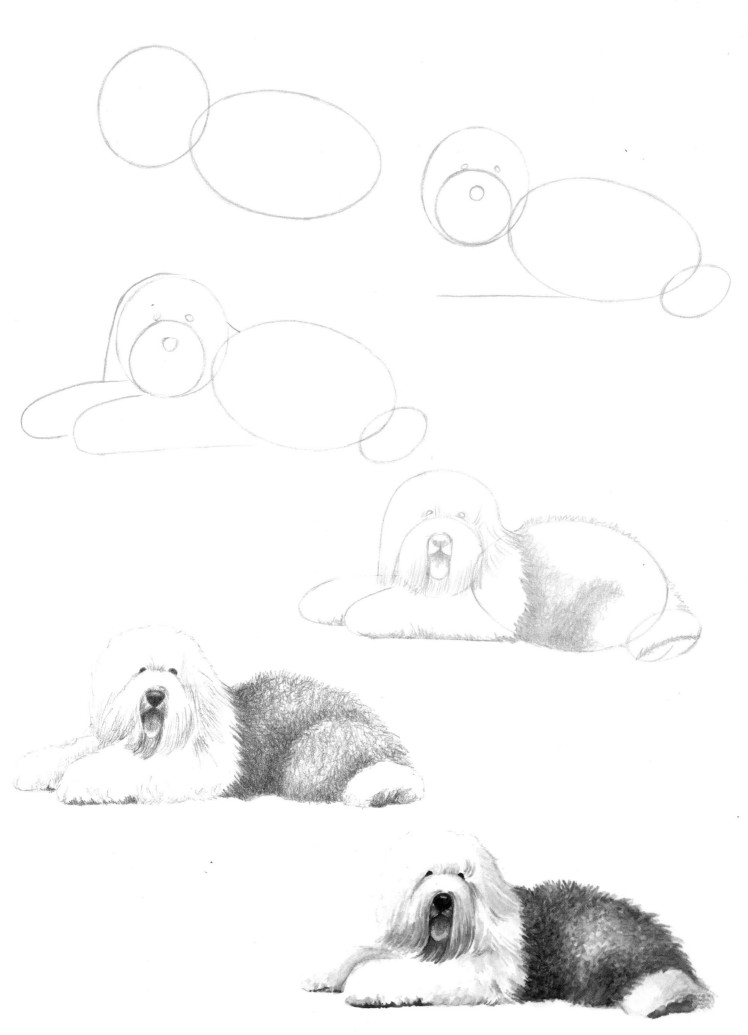

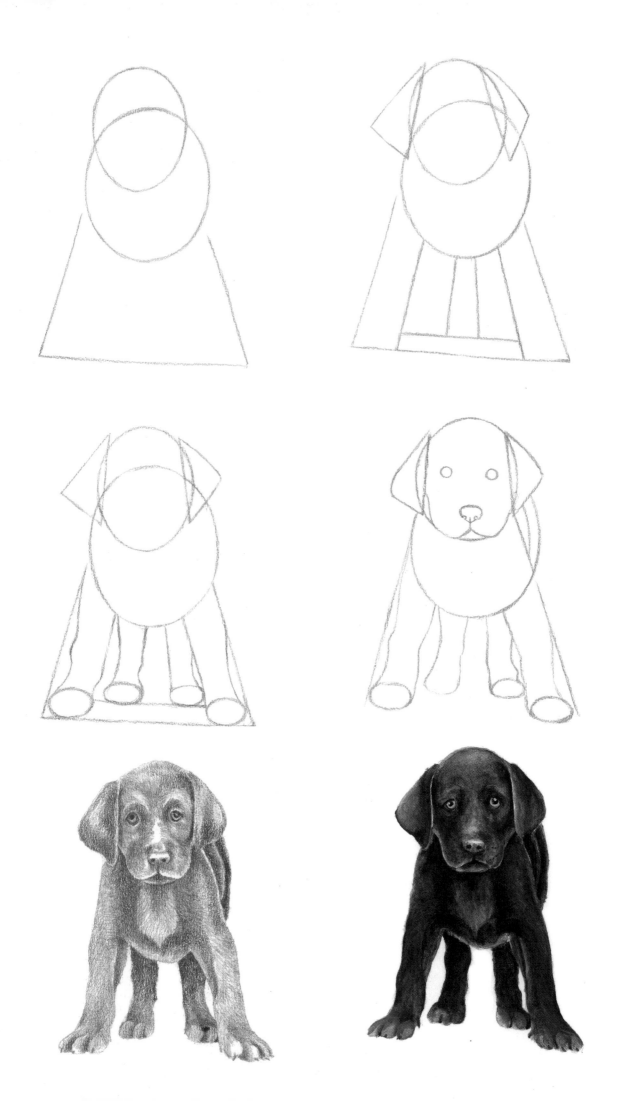

6

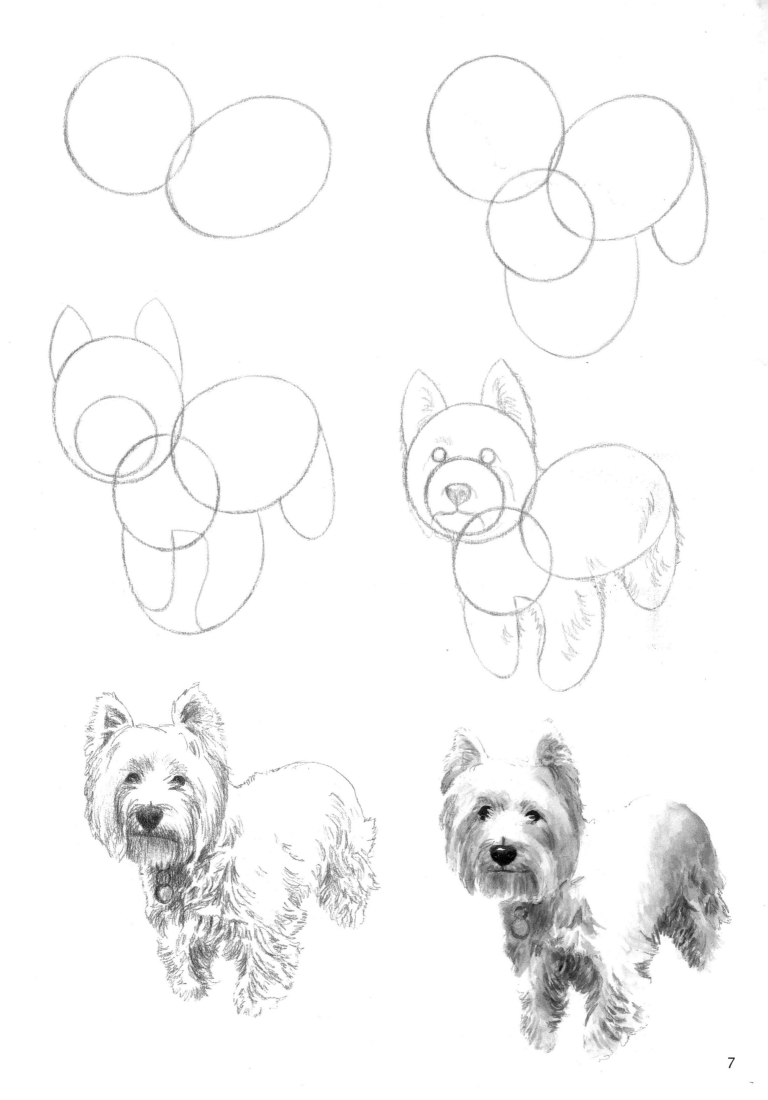

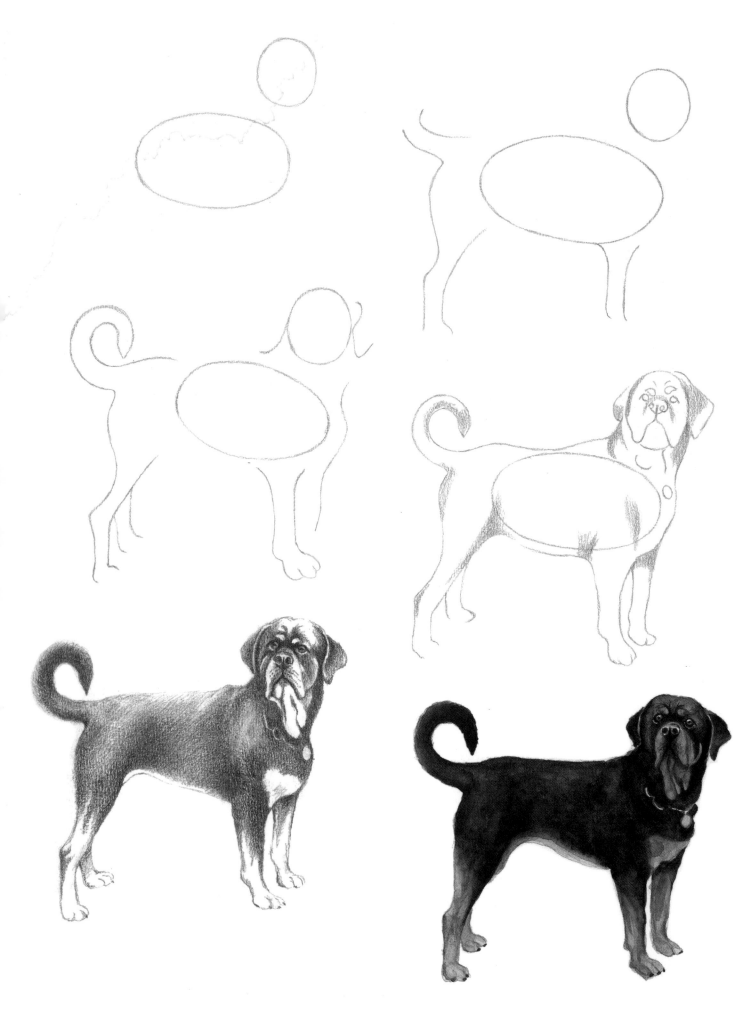

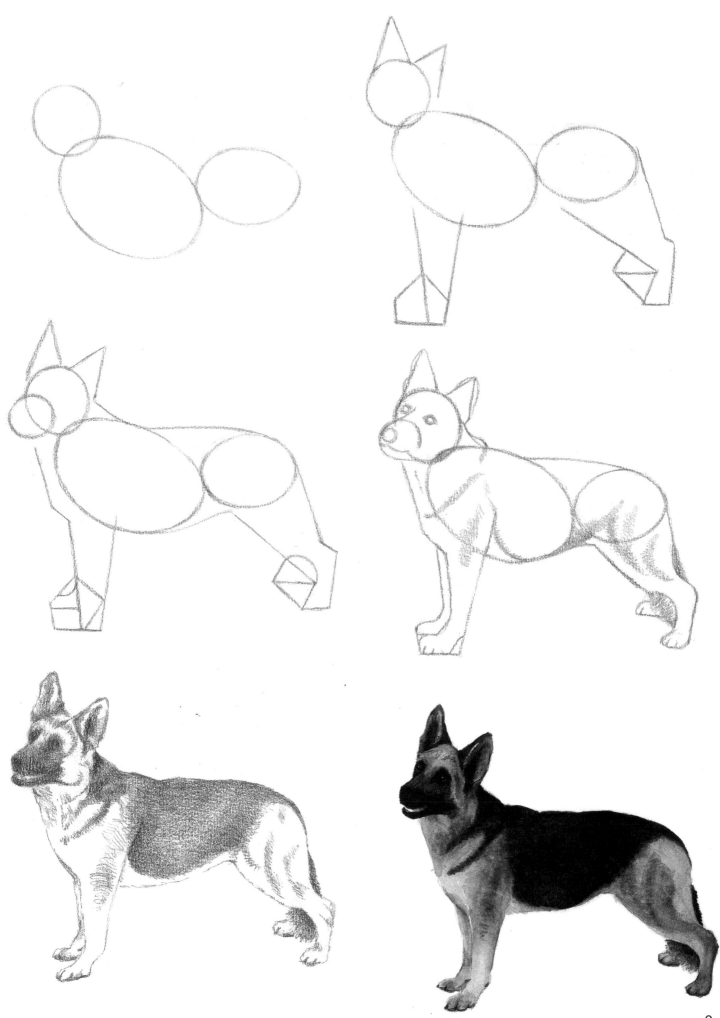

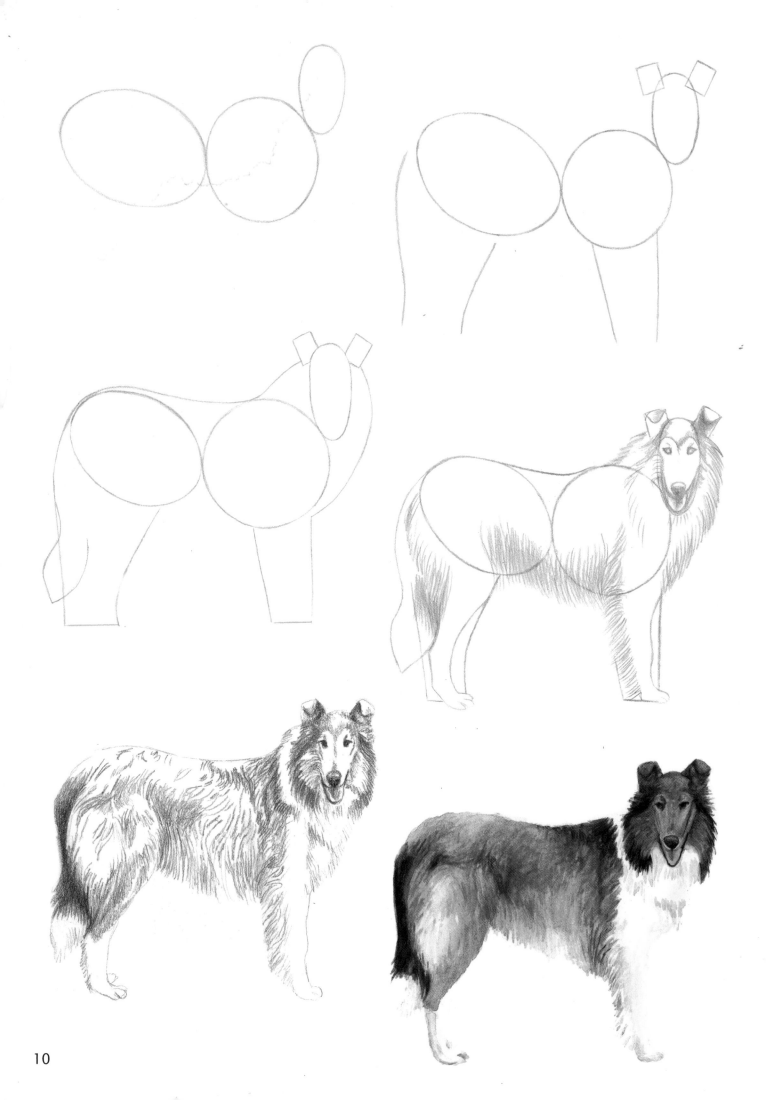

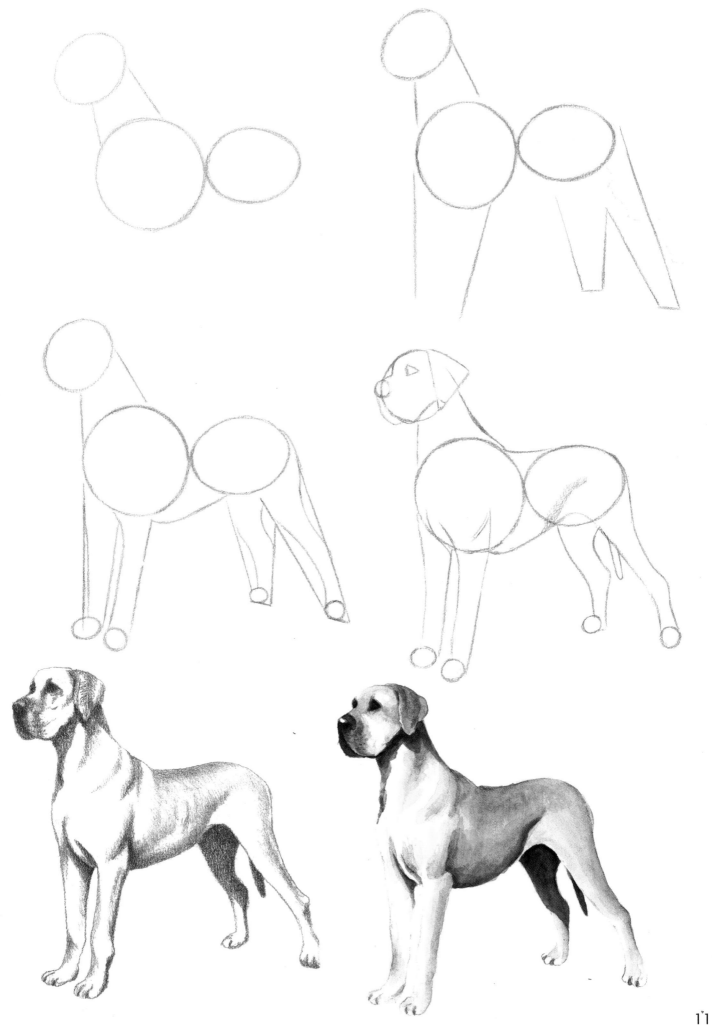

11

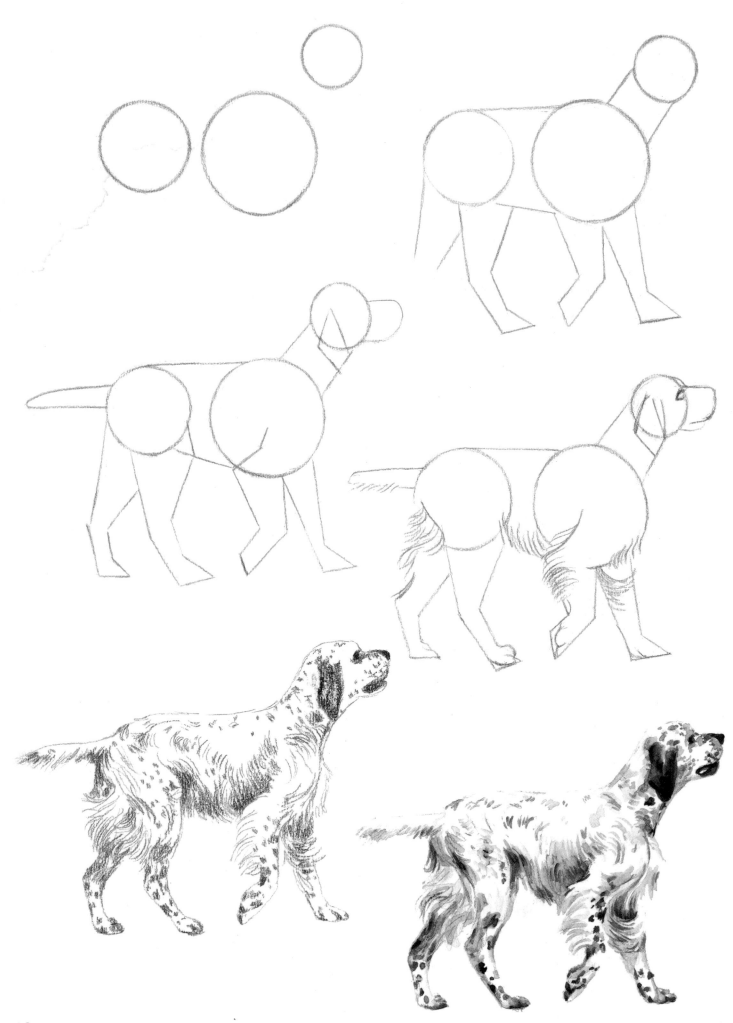

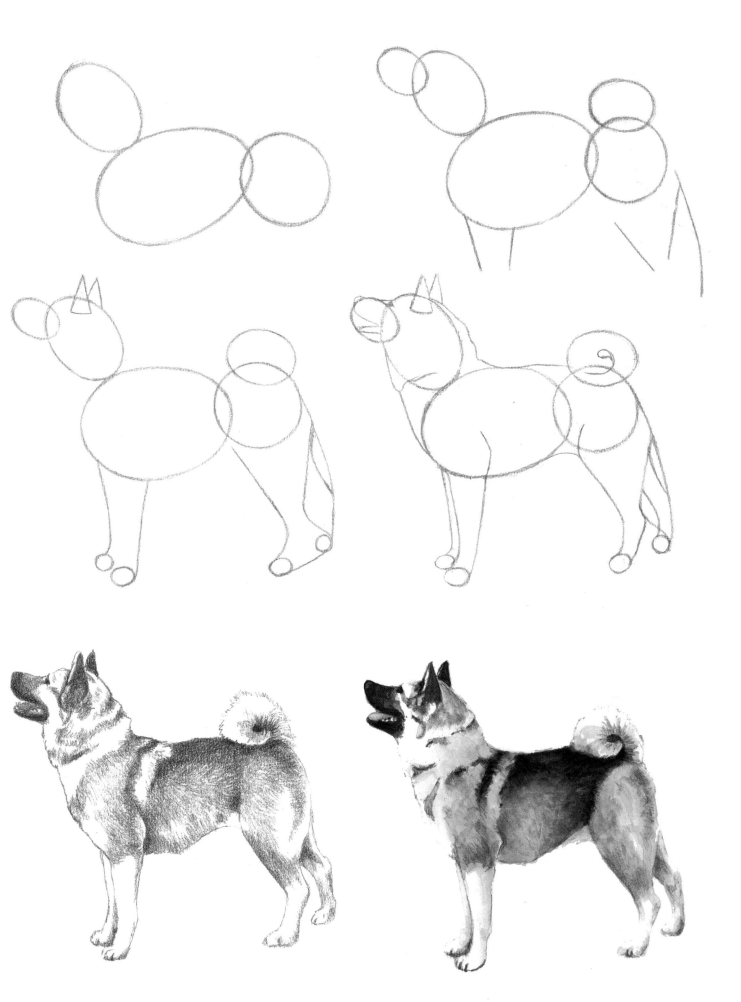

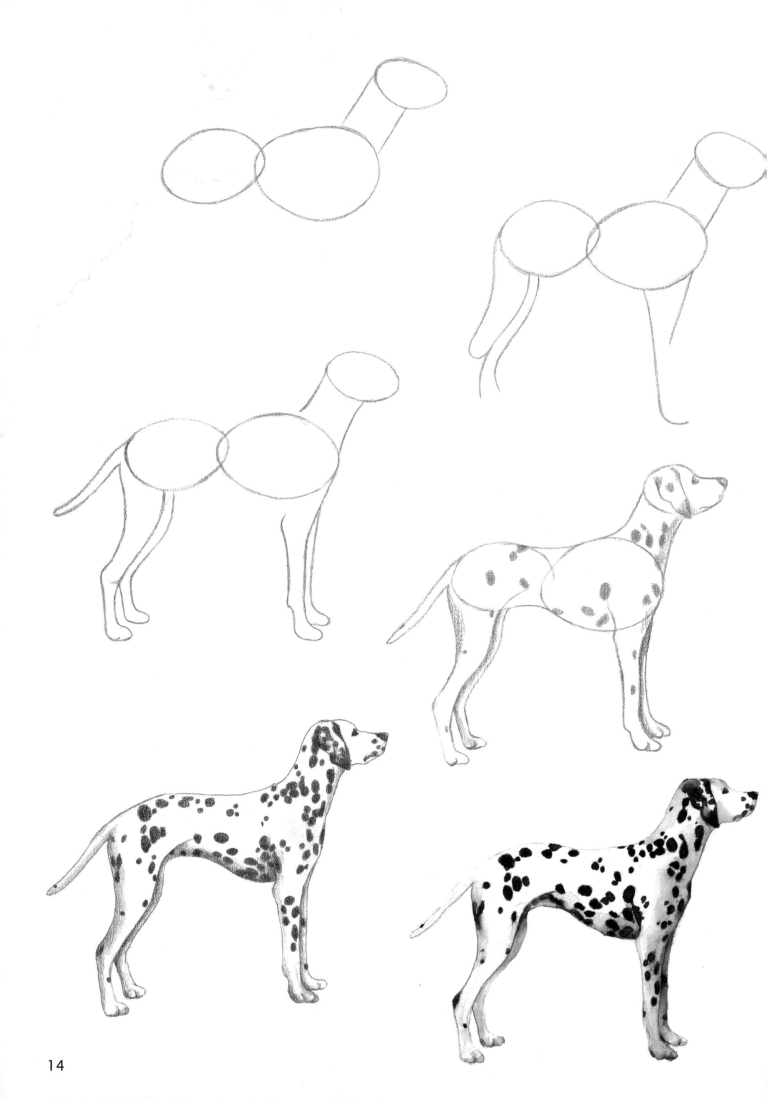

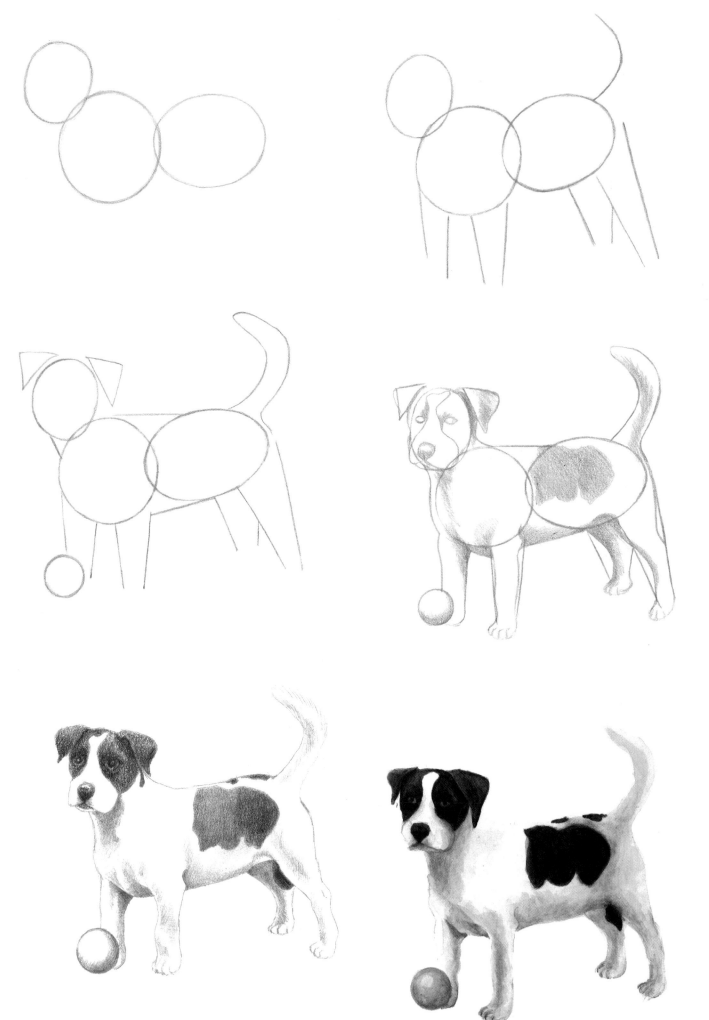

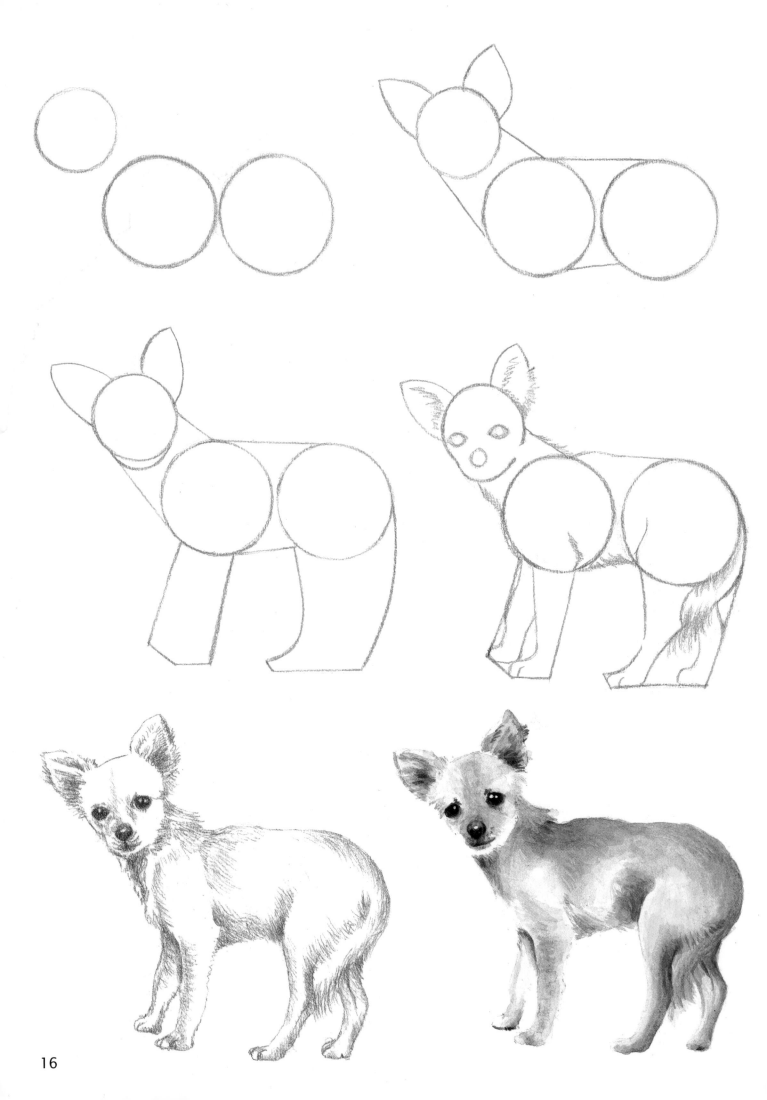

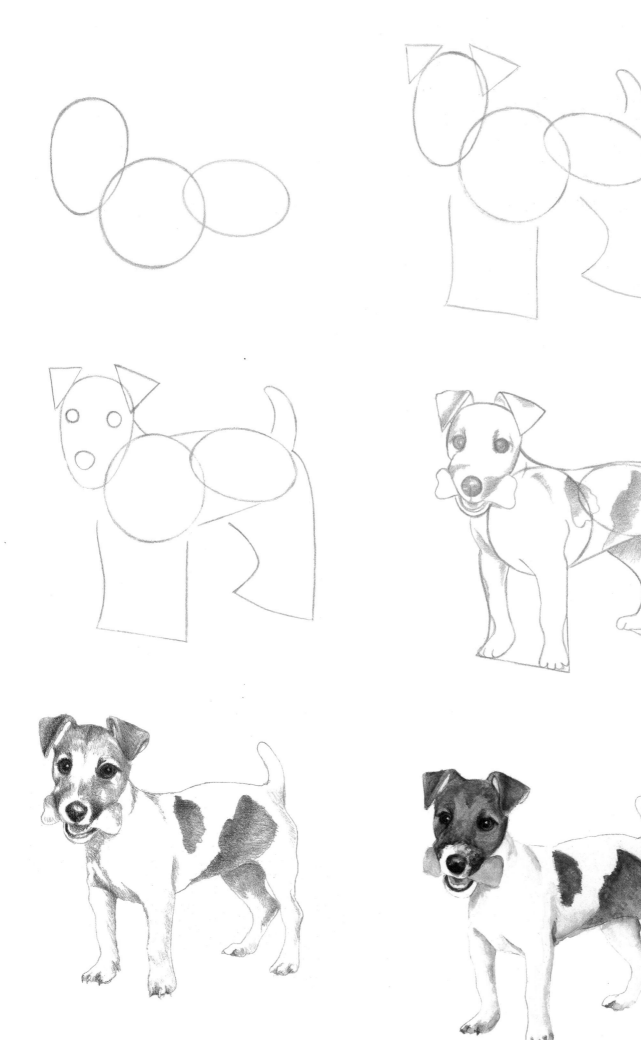

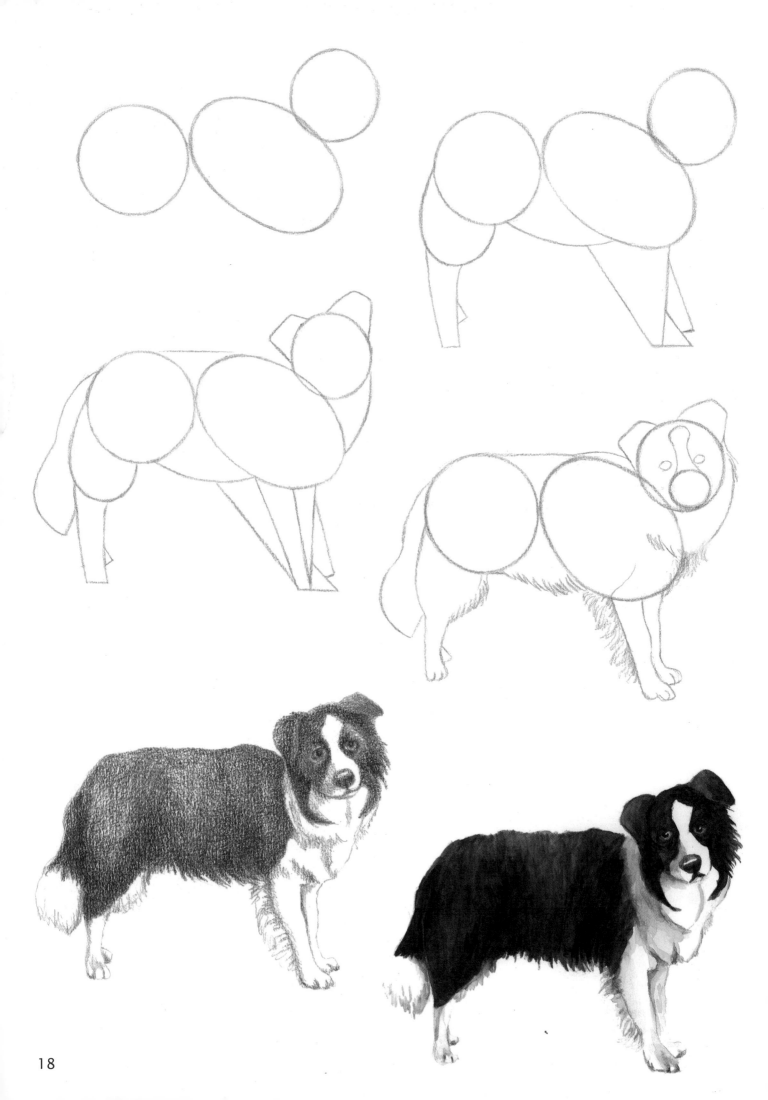

18

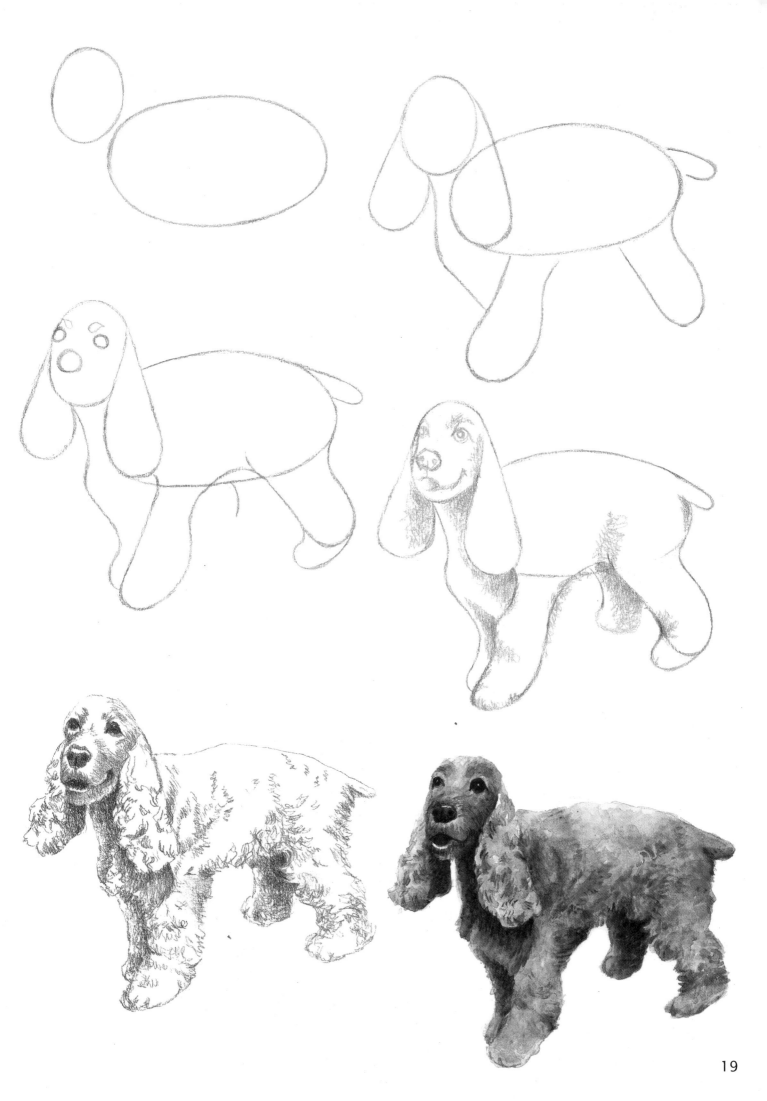

19

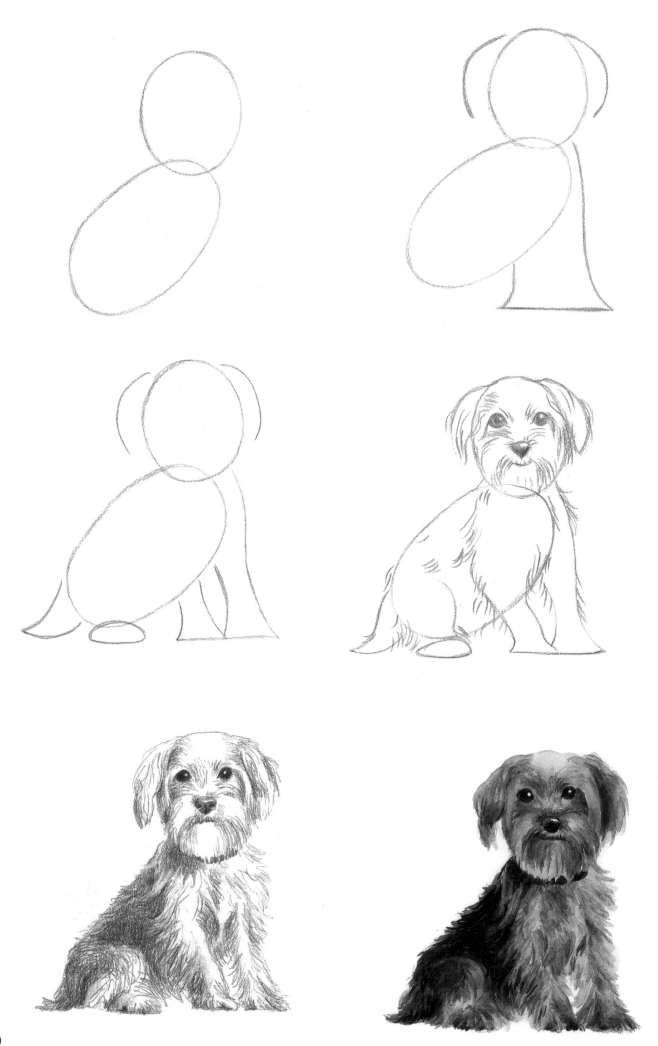

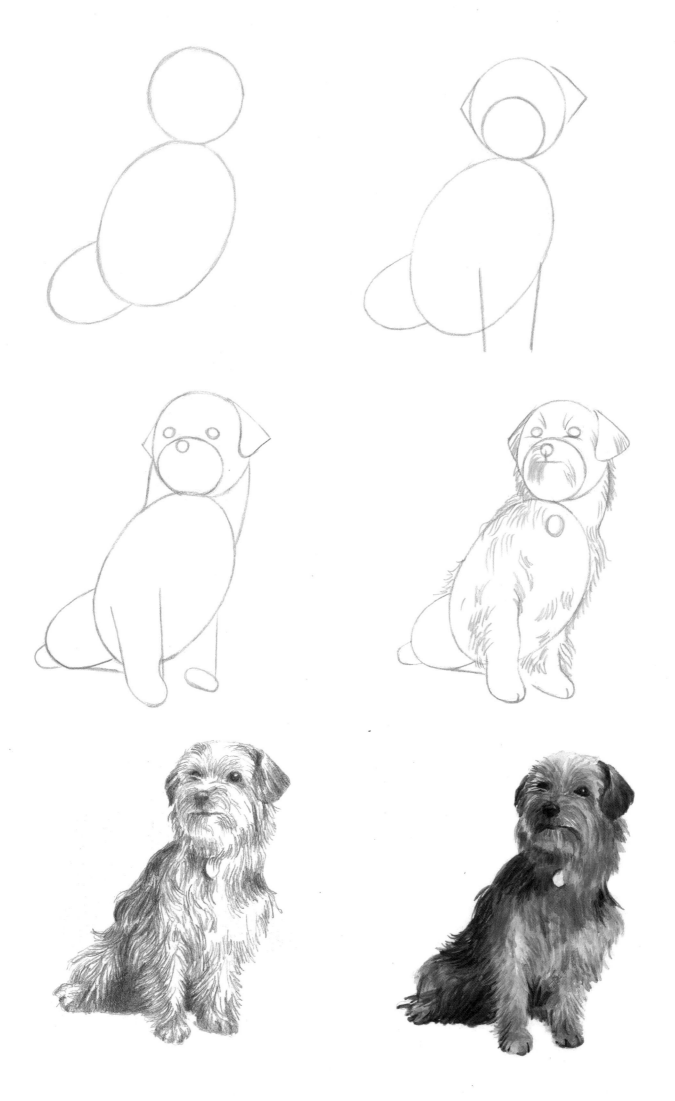

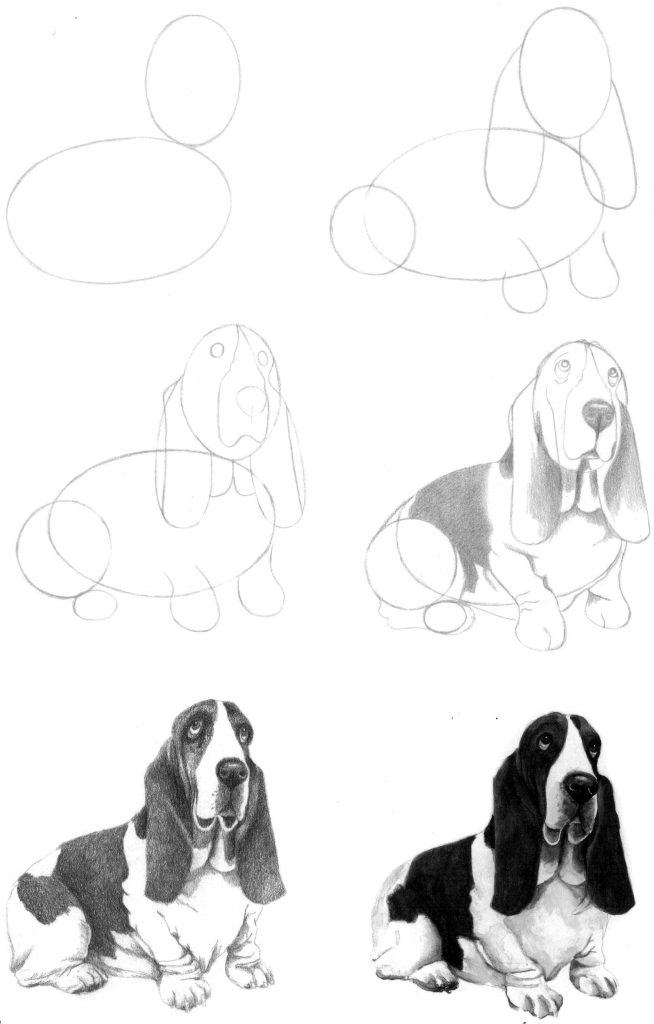

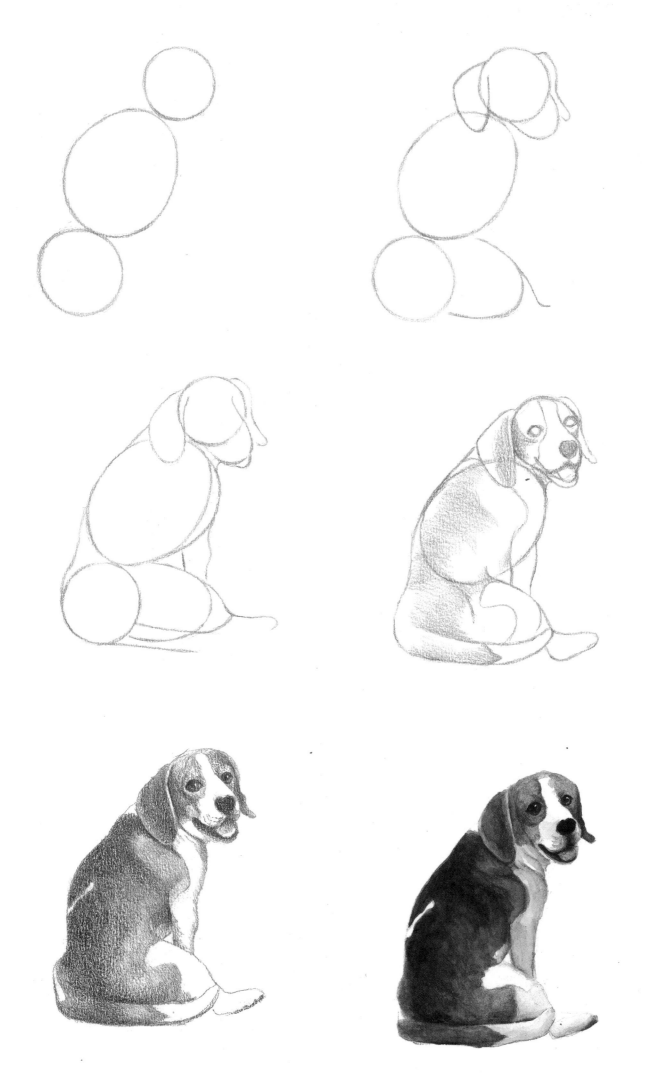

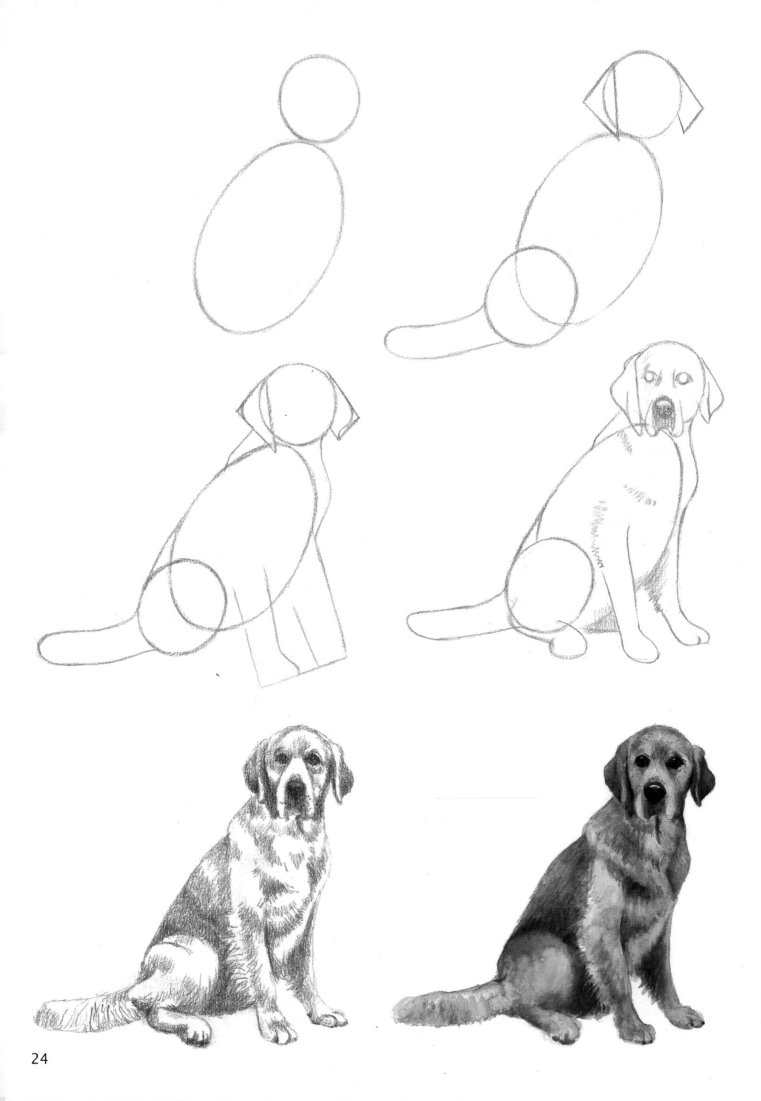

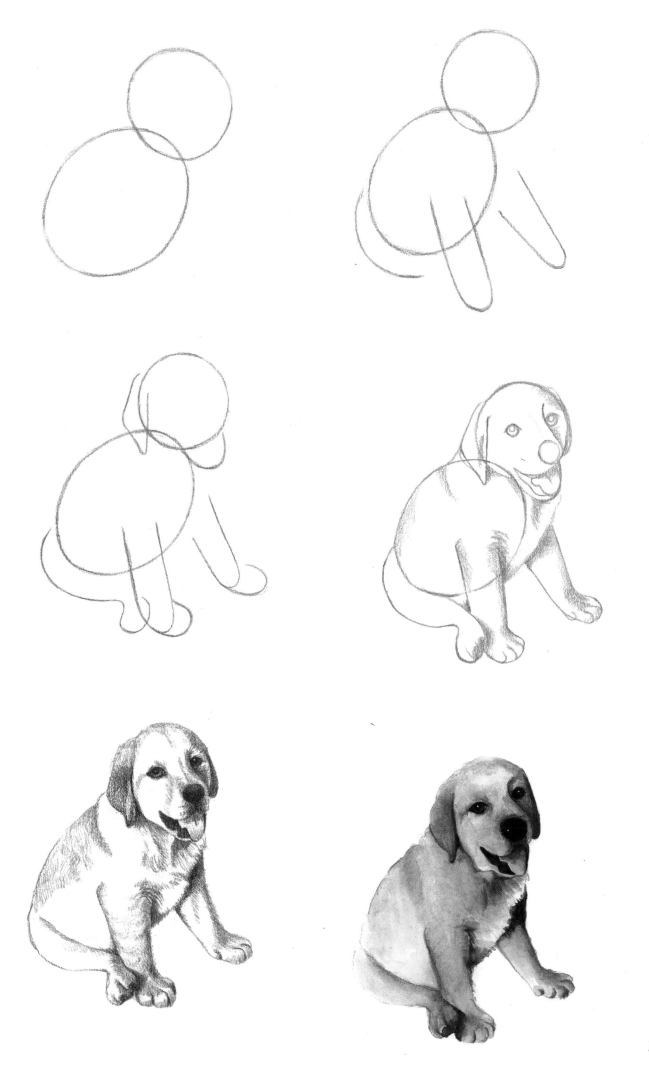

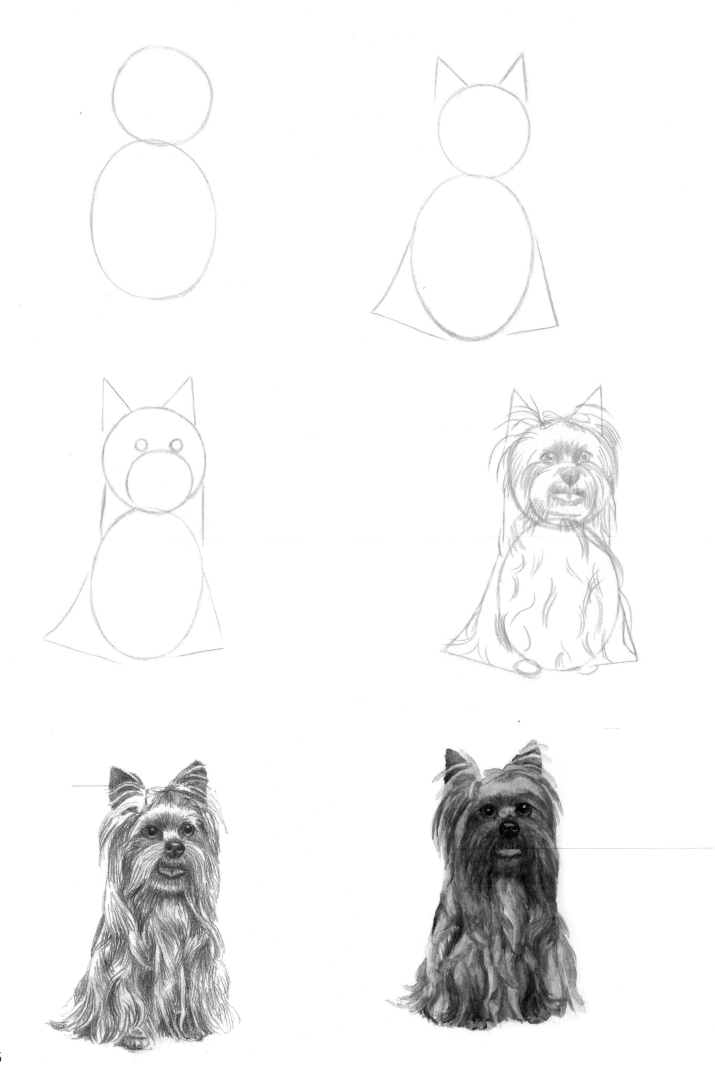

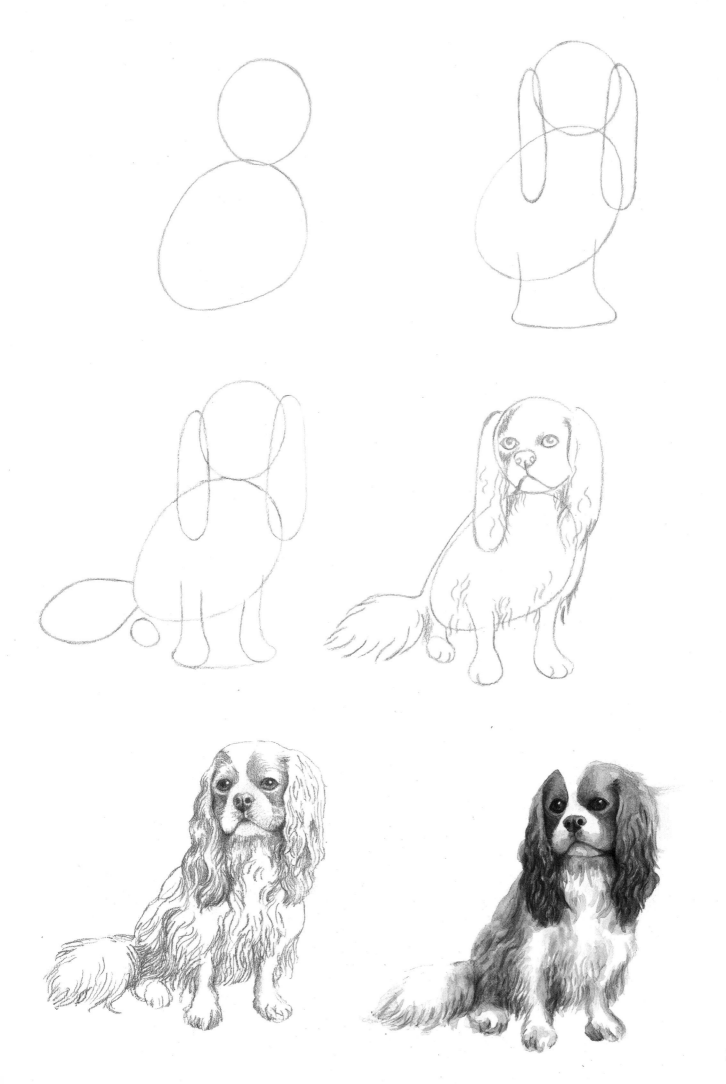

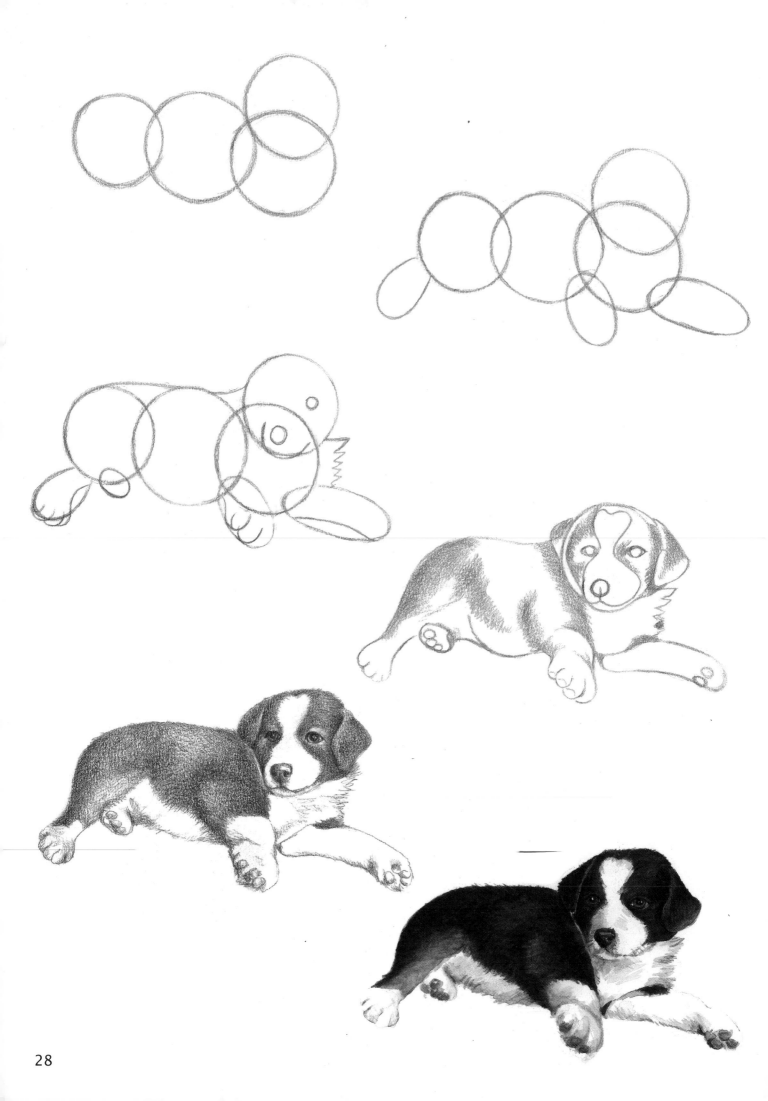

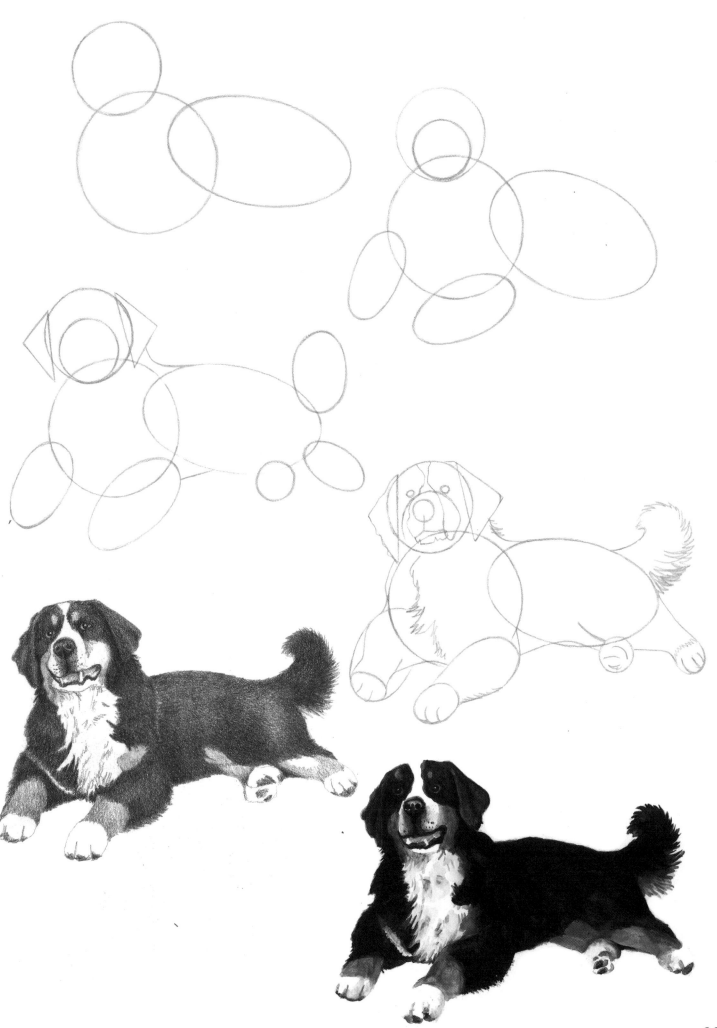

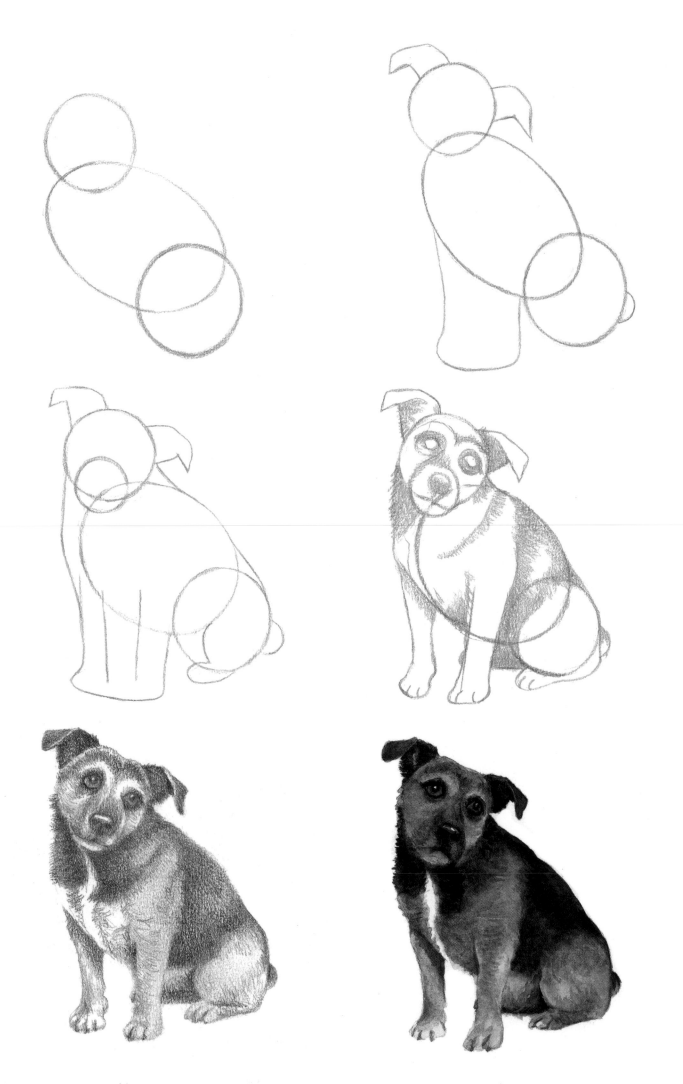